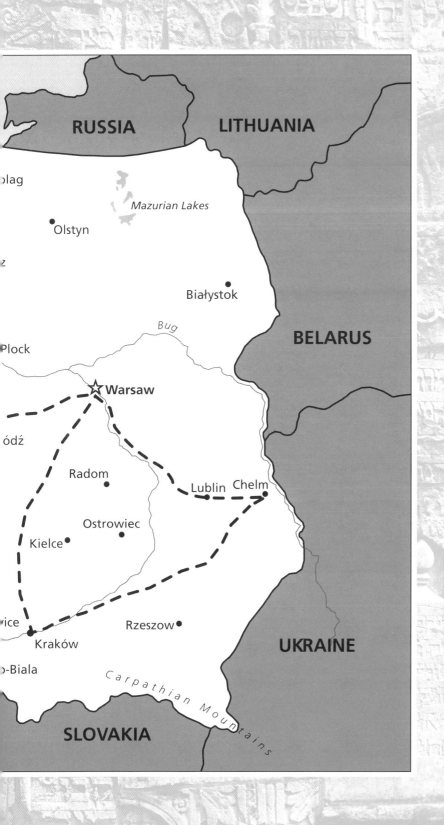

JOURNEY TO POLAND

Journey to Poland:
a family mission

PHOTOGRAPHY AND TEXT

David S. Greenfield

ACKNOWLEDGEMENT

THIS VOLUME, WHICH BEARS WITNESS to a pivotal chapter of 20th century history and watershed events in my family history, would not have developed without some special people. Most importantly, my wife, Carol, and children, Joshua and Naomi, with whom I share a passion for our Jewish heritage and family roots, enabled me to plan and chronicle this journey.

For more than twenty five years, Carol has been my partner in life and the number one proponent of my photographic endeavors. Always agreeing to revisit a site to capture it in better light, she would wait patiently as I searched for just the right perspective and moment to trigger the camera's shutter. Without her, I could not have achieved my current accomplishments in art, work and life.

Josh's vision for this "mission" is also noteworthy. His idea to use infra-red film helped impart an unearthly quality to images created in places where unspeakable crimes against humanity were committed 50 years ago. He also had the perseverance to circuit the Tube in London searching for the requisite film before our flight to Warsaw.

Naomi had an impact on this project from its inception. By keeping a daily journal throughout our travels, her heart and soul were transferred to the written page long before I thought to write my version. Her poignant account of the experience as seen through the eyes of a young girl, not unlike those of my mother when she endured her traumas, set the tone for me when I sat down to struggle with pen and paper. Naomi's writings have since been transformed into several powerful essays that continue to teach others, including members of our own extended family.

I also wish to thank Catherine Mayes, former curator of the Starr Gallery at the Leventhal-Sidman Jewish Community Center for prompting me to record the narrative I recited for her as she reviewed the unfinished portfolio. Catherine was the first to realize that a book about the journey needed to be produced.

Finally, my thanks to Bonnie Katz, the graphic artist who with great sensitivity helped me transform the formal exhibition of this photography into the volume you are about to view. The exhibition has been on display at the Boston and Newton Public Libraries as well as the Leventhal-Sidman and Striar Jewish Community Centers of Greater Boston.

To honor my parents, Rachele and Joseph —
for the courageous path they chose from darkness to new life

CONTENTS

PREFACE . 1

The Journey:

WARSAW . 2

DĄBIE . 4

CHELMNO . 12

LUBLIN . 18

CHELM . 20

ZOLTANCE . 24

KRAKOW . 28

OSWIECIM, AUSCHWITZ . 30

WARSAW . 38

NOTES . 40

"He who saves one soul, it is as if he saved a whole world."

the Talmud

M Y FATHER, Joseph Don Greenfield, is from Dąbie, a small town in central Poland. My mother, Rachele Bunis Greenfield, is from Kowel, a town which is now part of the Ukraine. They survived the war, met and married in a *Displaced Persons (DP) camp* in Austria, where I was born. With their families decimated and persistent anti-Semitism in their hometowns, my parents' hope was to reach *Palestine* and be part of the rebuilding of the Jewish national homeland. At that time of dispersion and homelessness, and with a sense of loss and isolation, they knew of no other option. Several unsuccessful attempts by the *Bricha*, the underground movement of survivors from Eastern Europe, to evade the British blockade and smuggle my parents ashore in Palestine followed. We were fortunate, however, to arrange passage to the United States in 1949 through the assistance of the *Hebrew Immigrant Aid Society (HIAS)*.

In the summer of 1993, I traveled with my wife and two teenage children to Poland. We wanted to investigate sites of importance to Jewish history in cities such as Warsaw, Lublin and Krakow. The primary mission, however, was to learn firsthand about our family roots by exploring my father's hometown, and to meet the family of the heroic Polish woman, Pani Anna Kucharska, who helped save my mother during the war. I also wanted to recite *Kaddish*, a prayer for the grandparents I never knew.

Our experiences created an emotional roller-coaster: the low of standing alongside the mass grave at Chelmno, the extermination center where my father's parents and relatives were gassed and cremated, to the elation of spending several days with the Wujastyk family, Polish Catholics whose matriarch helped hide my mother and her sister at great personal risk to herself and her family 50 years ago.

It was a journey and an adventure of a lifetime. Each of us was profoundly and irreversibly touched by people, places and experiences we encountered.

Explanations of and additional information about the italicized words can be found in ***Notes*** *at the end of this book.*

Okopowa Jewish Cemetery, Warsaw

W E LANDED IN THIS CAPITAL CITY under heavy cloud cover and in the midst of a soaking rain. Much of the architecture was drab and monolithic, having been constructed during the Communist Era to rebuild a city severely damaged during the war years. Our primary interest in Warsaw was to see historic landmarks in this once famous center of Jewish culture. To gain an appreciation of the culture which flourished in this city, one had only to tour the Jewish cemetery on ulica (ul.) Okopowa, the street located at the westernmost border of the former *ghetto*. This is the final resting place of many of Jewry's eminent rabbis, writers, politicians and performers. It remained relatively unscathed despite the virtual destruction of the *ghetto*.

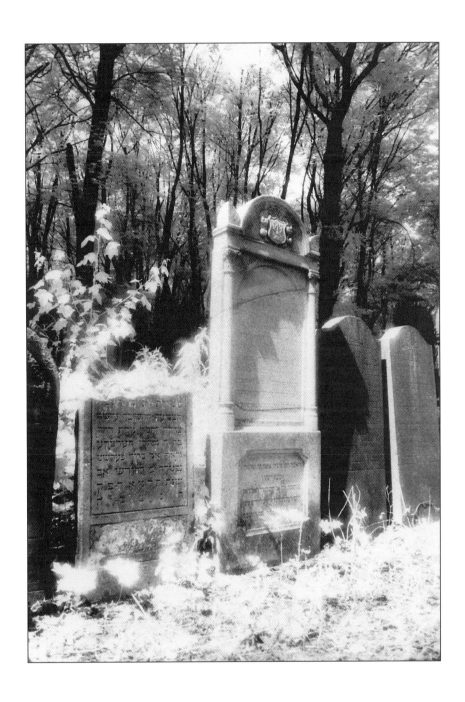

Dąbie, 1939

PRIOR TO OUR DEPARTURE for Poland, my father drew a map of his hometown of Dąbie as he remembered it in 1939. On it he located the familiar landmarks around the town square: the gasoline and water pumps, the bridge spanning the Ner River, the synagogue, the Catholic church, and the roadways leading to the neighboring towns in the district — Klodawa, Grabow and Chelmno. He also precisely noted the site of his boyhood home on a narrow side street named ul. Kilinskiego.

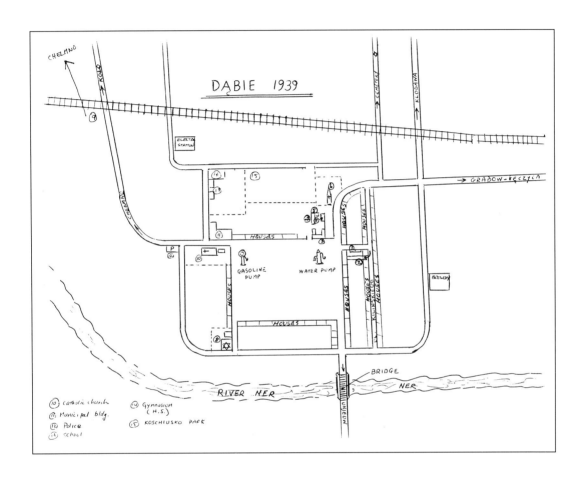

DABIE 1939

10 Catholic church
11 Municipal bldg.
12 Police
13 school

14 Gymnasium (H.S.)
15 KOSCHIUSKO PARK

ul. Kilinskiego, Dąbie

WE LEFT WARSAW and drove for two hours, winding our way through an endless series of towns and villages until we reached the outskirts of Dąbie. Once in the central square, we were immediately surrounded by a band of inquisitive kids who followed us as we searched, with the help of the map and a Polish interpreter, for my grandparents' former apartment on ul. Kilinskiego. The gentleman in the photo was a fountain of historical information. During conversation, he recalled the Greenfield family and their shoe shop. He also remembered my father's uncle, the photographer, and his little studio. At this point, I was very excited to have used the map to find my father's birthplace and to have come across an elderly resident who remembered my grandparents. In the initial euphoria, I never thought to ask permission to go inside the apartment. It was only a short while later that I began to wonder how the current residents got possession of this property which used to belong to my family. Were their relatives willing occupiers of vacated Jewish homes when the *ghetto* in Dąbie was established? Did they collaborate and identify homes where Jews could be found? I never found out. The questions still haunt me.

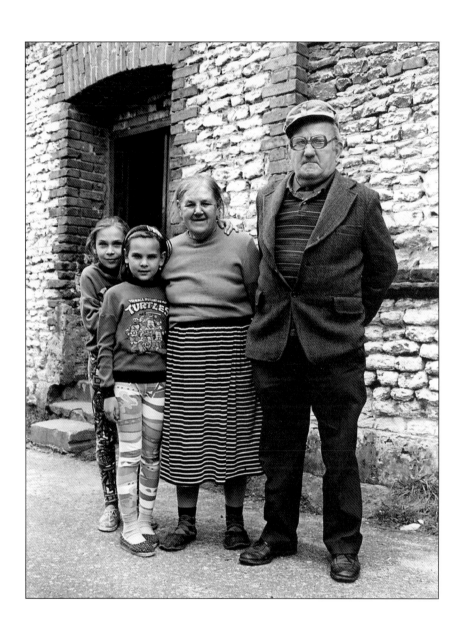

Young Boys, Dąbie, 1993

THESE BOYS WERE AT PLAY in front of the house where my father lived. They seemed so carefree, as young teenagers should during the summer months. As I stood there, my thoughts drifted to those few precious moments when my father would give me a vignette of his teenage years in Dąbie before the war. He attended *gymnasium*, was a member of a *Zionist* youth movement, and often shared coffee and pastries at a cafe with his girlfriend. Unlike my newfound Polish friends in the doorway, my father would not fully savor his adolescent years, which were suddenly truncated by the start of the occupation. Instead, he had to grow up much too quickly at places like *Mauthausen* and *Auschwitz*.

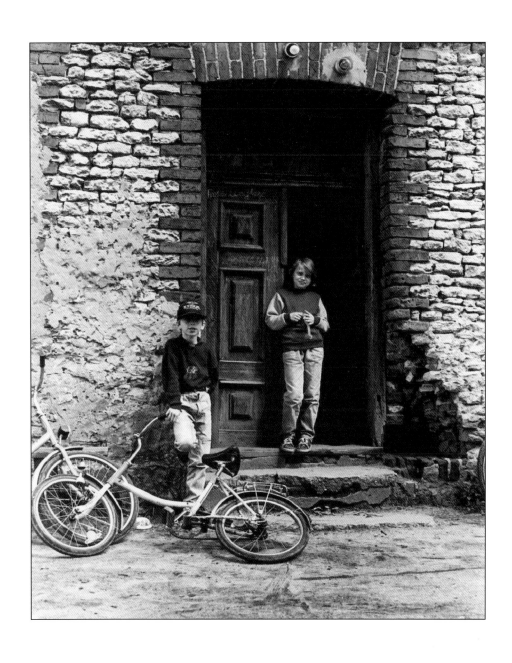

Synagogue, Dąbie

THE SYNAGOGUE IN DĄBIE is an historic structure erected in 1895. The majestic lines and arches of the exterior architectural design remain intact. Today, however, its "soul" serves as housing units. Rather than being graced with an *aron kodesh* or *magen david*, drying laundry adorns its sides. There are no Jews left in Dąbie.

THE LETTER ON THE RIGHT was received by my father while in a ***Displaced Persons camp*** in Austria after the war. It was sent by J. Podgorski, a Pole from my father's hometown of Dąbie, who worked for my grandfather in his small shoe manufacturing shop. The letter provides an eyewitness account of the deportation of the Jewish population of Dąbie to the nearby extermination center at Chelmno. The deportation of Dąbie's remaining 920 Jews took place in mid December, 1941 after an earlier ***Aktion*** in which my father, referred to as Mr. Josko, his brother Mendus, as well as other young men and boys, were taken into forced labor by the ***Nazi*** occupiers. This letter and a subsequent one in November confirmed for my father the fate of his family. Only he and his brother had survived.

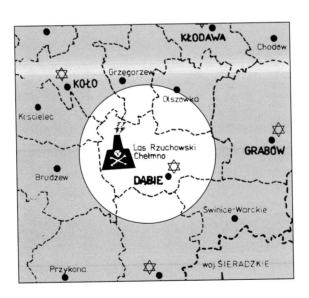

Dąbie, *April 28, 1946*

Dear Mr. Josko!

...Now I would like to congratulate you and your brother on your survival
from the German hell and living to see real freedom. I'm so happy to hear
from you. I'm very sorry that I have to give you bad news but I think bad
truth is better than golden uncertainty. Mr. Josko, you saved your father
from forced labor and went there in his place. But your father died for you
because soon after you left, Germans—or rather Nazi murderers—took all
Jews from the town of Dąbie, put them first in the Catholic church and in
the fire station, and then took them in trucks to Chelmno and murdered
them all. I think that you both know German methods of murdering so
I won't write about this. If you read about Oswiecim, Majdanek, Groshausen,
and other death camps you will know what we had in the town of Chelmno
and in the Rzuchowski Forest. We also had crematories here. Germans
behaved so horribly that even the hardest Poles cried and talked about
revenge. Mr. Josko, I have to confess that in the beginning for about four
weeks I didn't believe that such cruelty can happen on this world even
though every day I've seen convoys of German trucks passing by my window.
And it wasn't until four weeks later that I calculated that Rzuchowski
Forest wouldn't be able to accommodate so many people. I've seen no food
deliveries and it was only then that I realized that there is a government
that will murder innocent people without a trial. I'm so sorry...

Please answer fast. Regards from my wife, brother and sister,
Always your sincere friend,

J. Podgorski

Rzuchowski Forest, Chelmno

CHELMNO IS 6 KILOMETERS AWAY on the road leading out of Dąbie. It has the infamous distinction of being the site of early *Nazi* experiments with *gas chambers*, i.e. transports with exhaust re-routed to the passenger compartment. The camp was in the midst of the Rzuchowski Forest, an eerie and densely wooded area from which cries and screams could hardly be heard. There were several mass graves in this huge clearing. Threatening clouds darkened the sky as if in response to our realization of what had occurred on this ground 50 years ago. I placed a stone at the edge of the crude gravesite and, with the help of my family, recited *Kaddish* for my grandparents while choking back a torrent of tears I never knew I was capable of shedding.

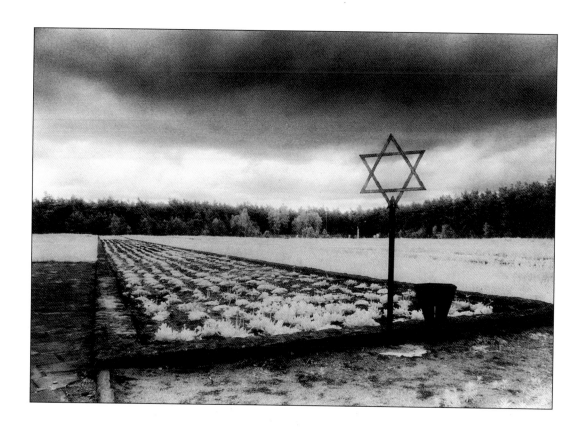

MEMORIAL INSCRIPTION, CHELMNO

FROM INFANTS TO THE AGED —
 WE WERE TAKEN FROM THE TOWNS OF KOLO AND DĄBIE.

WE WERE TAKEN TO THE FOREST AND THERE WE WERE PUT TO DEATH BY GAS,
 SHOT WOUNDS AND FIRE.

WE ARE PLEADING WITH OUR BROTHERS TO PUNISH THE MURDERERS,
 THE WITNESSES TO OUR PLIGHT, WHO LIVE IN THIS AREA.

ONCE AGAIN WE CRY OUT —
 LET THE MURDERERS BE KNOWN THROUGHOUT THE ENTIRE WORLD.

A grim exhibit was housed near this massive memorial. On display inside were *Nazi* records of the liquidation of the Jewish population in the surrounding district. We read that 920 Jews from Dąbie were transported to Chelmno between December 14th and 19th, 1941. In total, approximately 350,000 Jews were turned to ash at Chelmno.

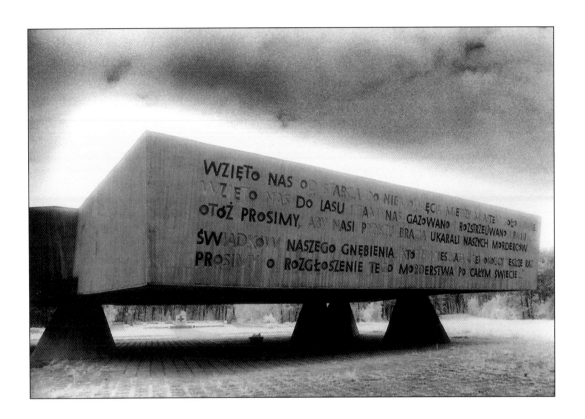

"BATHHOUSE"— DELOUSING SECTION IN MAJDANEK CAMP, LUBLIN

AFTER COMPLETING OUR MISSION in Dąbie and Chelmno, with its grim reminder of the depths to which man's inhumanity to man can sink, we anxiously anticipated the meeting with a family which represented the good that is also within us. Our journey continued on a route from Warsaw to Lublin. As the road passed by this famous center of Jewish learning, we were shocked to see the former concentration camp, *Majdanek*, immediately bordering the city. As I think back, I realize no sight on the entire trip was as disturbing to me as this death camp in plain view of the city. How could the residents not see, hear, or even smell the evidence of the atrocities at this infamous center? The answer is sadly obvious.

Pani Anna Kucharska

For a Jew today, Poland is a cemetery. For my family, however, the country has another facet embodied by Pani Anna Kucharska, a Polish Catholic who lived on a farm neighboring my mother's home in Kowel. When the danger of the *Nazi* occupation became too great, my grandparents sent my mother and her older sister away to hide in the adjacent forests. When they needed shelter from the cold, Pani Kucharska, at mortal danger to herself and family, and unbeknownst to her husband, allowed the sisters to use her barn and occasionally provided small scraps of food saved from her own meager table. She never asked for anything in return. The sisters had nothing to offer.

```
                                    Mrs. Rachele Greenfield
                                    56 Clubhouse Lane
                                    Marlboro, New Jersey 07746
                                    U.S.A.
                                    March 17, 1990

Institute of National Memory
Yad Vashem
P. O. Box 3477
Jerusalem, Israel  91034.

Sirs:

This is to acknowledge the indisputable fact that Mrs. Anna
Kucharska, 22-100 Chelm Lubelsky, Wies Zoltance, SKR. 2-8,
Poland, at the risk of her own life and the lives of her
family, without any personal gain, or renumeration of any
kind - saved the lives of my sister Pinia Bunis and myself
Rachela Greenfield nee Bunis.

The above occurred at Nova Dombrova, Poviat Kovelski, Poland,
during the period of 1942 through 1944.

I appreciate your putting the above in your records.

                              Sincerely yours,

                              Rachele Greenfield

                              Rachele Greenfield
                                   nee Bunis
```

Rachele and Anna, Zoltance, 1979

Karen Grayson
KAREN A. GRAYSON
NOTARY PUBLIC OF NEW JERSEY
My Commission Expires Feb. 6, 1995
March 19, 1990

RIGHTEOUS AMONG THE NATIONS

IN RECOGNITION OF HER HEROISM, the Israeli Special Commission for the Designation of the Righteous conferred the State's highest expression of gratitude to Pani Kucharska, the medal and title of **Righteous Among the Nations**. Her name was subsequently inscribed on the **Wall of Honor** at *Yad Vashem* in Jerusalem. The awards were conferred in November, 1992. Pani Kucharska had died just two months earlier.

YAD VASHEM יד ושם

The Holocaust Martyrs' and Heroes' Remembrance Authority רשות הזיכרון לשואה ולגבורה

Jerusalem, 12 November 1992

Mrs. Anna Kucharska
Wies Zoltance
22-100 CHELM LUBELSKI
POLAND

Dear Mrs. Kucharska,

I have the pleasure to inform you that the Special Commission for the Designation of the Righteous, at its session of 4.10.1992 decided to confer upon you its highest expression of gratitude: the title of Righteous Among the Nations.

This recognition entitles you to a medal and a certificate of honour and the privilege of having your name listed on the Righteous Wall of Honor, at Yad Vashem, Jerusalem. Please be in touch with our embassy/consulate in Warsaw (Mr. Ami Mehl, ul. L. Krzywickiego 24, Tel: 250028) for further information on the distribution of the awards.

With our best wishes.

Sincerely yours,

Dr. Mordecai Paldiel
Director
Dept. for the Righteous

Commission/M.P./S.O./

5464#

cc: Mr. Ami Mehl, Embassy of Israel - Warsaw
 ZIH - Poland
 Mrs. Rachele Greenfield - USA

P.O.B. 3477, JERUSALEM 91034, TEL. 751611, FAX. 433511. פקס,751611 .טל ,91034 ירושלים ,3477 .ת.ד.

FARM IN ZOLTANCE

WITH POLISH BORDERS REDRAWN after the war, Pani Kucharska's farm and my mother's former home in Kowel became part of the former USSR. The Kucharskas moved west to the village of Zoltance to remain within Poland. Although they did not meet after liberation until 1979, my mother had remained in contact with Pani Kucharska until her death, and continues to call, write letters and send packages to Pani's son, daughter and grandchildren.

When we arrived in Zoltance, to the farm on which Pani Kucharska had lived, I was drawn to the barn. Although it was not "the" barn in which my mother sought refuge, the setting was the same; a few exterior loose boards that served as a secret entryway, and the piles of hay next to the cows that provided bedding and an additional hiding place during random searches. It was always hard to imagine how young girls could leave their home and be in hiding for years. Seeing the countryside and the "hiding spot" did not make it easier.

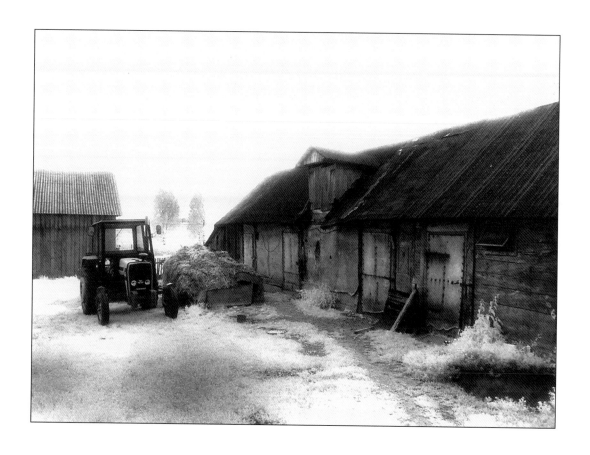

THE WUJASTYK FAMILY REMEMBERS

THE WUJASTYK FAMILY has three daughters, Edytka, Agatka and Rennatka. They are Pani Kucharska's grandchildren. Only the youngest, Rennatka, spoke sufficient English to facilitate conversations. Most of the time, however, the circumstances that bound our families together created a communication that transcended the spoken language.

The Wujastyks are deeply religious people and our presence in their home seemed like nothing less than a visit by an official of the Catholic church. We were tangible evidence of a lifeline sustained by the bravery and unselfish actions of their family matriarch. The daughters revered their grandmother and learned a considerable amount about the war years from her. They certainly learned more than I did from my mother who until recently remained very secretive about her experiences. At times when we were together, we would touch upon a subject that triggered thoughts of Pani Kucharska and her stories. Sitting in the field near the farm, it was as if time stood still as Agatka repeated some of the anguishing tales they heard from their grandmother. There were also stories about my mother and her family that I had never heard and may never have heard had it not been for our journey to Zoltance.

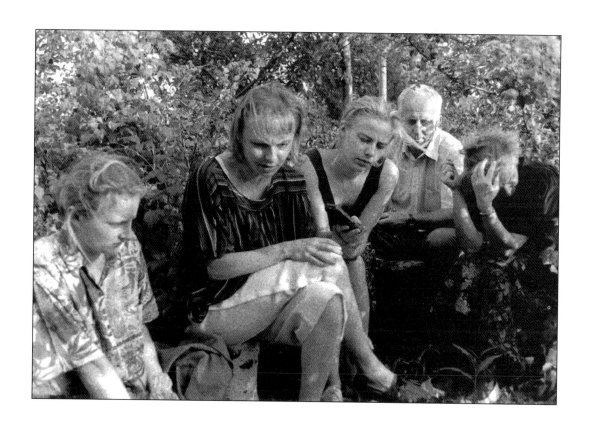

"The Kotel" - Remu Synagogue, Krakow

IT WAS A TEARFUL FAREWELL as we left the Wujastyk's home. We all knew that it was uncertain when, if ever, we would meet again. It was certain though, that we would not forget the days we spent together. It would be hard to imagine another meeting in our respective lifetimes that would represent such an emotional "reunion."

Our journey now took us south to Krakow, home to **Schindler's Jews** and the once flourishing **Kazimierz Jewish Quarter**. A small but aging congregation still exists here at the Remu Synagogue. We met the **gabbai** who brought us to the synagogue's **"Wailing Wall,"** or **"Kotel,"** a detail of which is pictured here. During the **Nazi** occupation, not only were Jewish lives violated, but the memory of those who had already been buried was desecrated. Otto Wachter, the **Nazi** district governor in Krakow, ordered the destruction of gravestones in this ancient cemetery. Some broken pieces were preserved, and after the war a wall composed of these shards was constructed within the area of the cemetery. A casting of a section of this wall is on display at the **U.S. Holocaust Memorial Museum** in Washington, D.C.

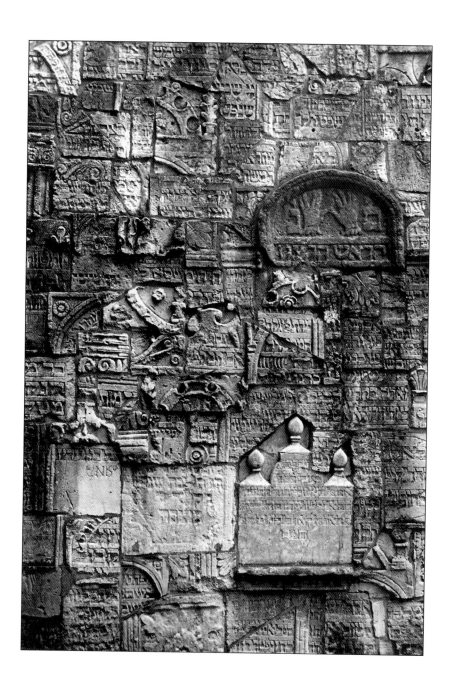

OSWIECIM

ON THE OUTSKIRTS OF KRAKOW at an important railway junction was the small provincial town of *Oswiecim*. In an area isolated from the center were several old deserted Polish military barracks. After the German *blitzkrieg* of September, 1939 and the defeat of Poland, this town was incorporated into the Third Reich. With the existing prison overcrowding in the adjacent Silesia sector, and in anticipation of pending waves of mass arrests in the rest of occupied Poland, the German High Command gave the order to proceed with expansion and conversion of the existing facility at *Oswiecim* to a concentration camp. The first prisoners were transported to the camp in the summer of 1940. By that time the town's Polish name had been changed to its German moniker, *Auschwitz*.

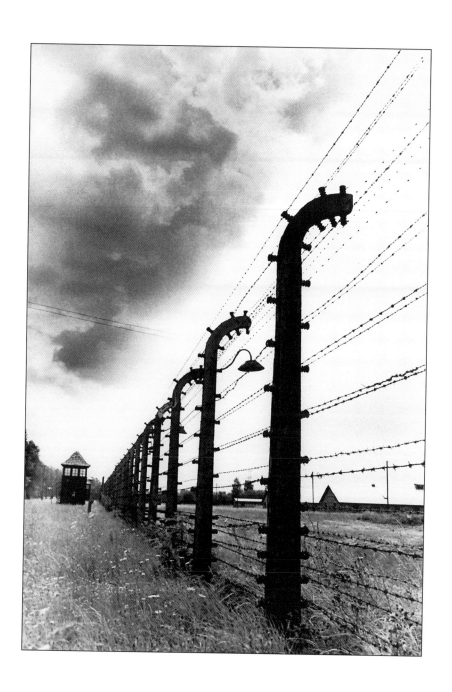

Auschwitz

A S THE NUMBER OF INMATES continued to increase, the camp at *Oswiecim*, **Auschwitz I**, with its infamous entry sign *"Arbeit Macht Frei,"* spawned a whole generation of new camps, forming a sprawling complex in the Polish countryside.

Auschwitz II, or Birkenau, was the actual killing field. It was an area several football fields in size with remnants of massive *gas chambers* and *crematoria*. At the height of operation of the *Final Solution,* more than 5,000 Jews were turned into smoke daily at each of the four huge *crematoria*.

Auschwitz III was comprised of smaller labor camps in the nearby town of Monowitz, which provided slave labor to various German industrialists such as *I.G. Farben*. One such camp, *Buna*, held my father as a prisoner.

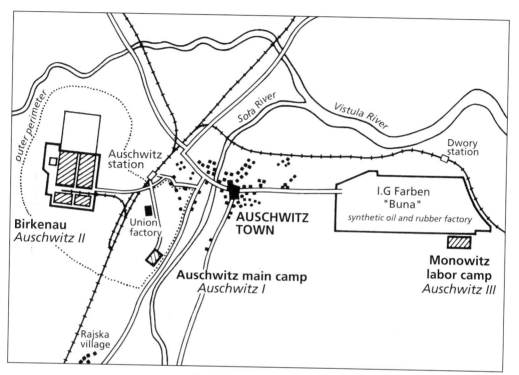

The Three Camps of Auschwitz

Birkenau, Auschwitz II

THE GAPING ARCHWAY at the entrance to *Auschwitz-Birkenau* was the last stop on the cattle car for millions. As we drove the 3 kilometers from *Oswiecim* to this camp, what enfolded before us was the largest death factory in human history. Standing next to the railway lines that were routed here from all parts of Europe, I was astounded at the enormity of the complex. As far as one could see in all directions were remnants of barracks that once held Jewish inmates. During our walk through the camp, a thunderstorm moved quickly into the area. We were caught hundreds of yards from shelter as the skies opened up with lightning, rain and hail. It was a terrifying 30 seconds which seemed like hours as we sprinted for cover. Once safely in an enclosure, I tried to comfort my daughter who had become almost inconsolable with fear. I thought about those Jews trapped here 50 years ago. They were totally exposed and vulnerable as we had just been for a brief moment. They, unfortunately, had no place to run and hide.

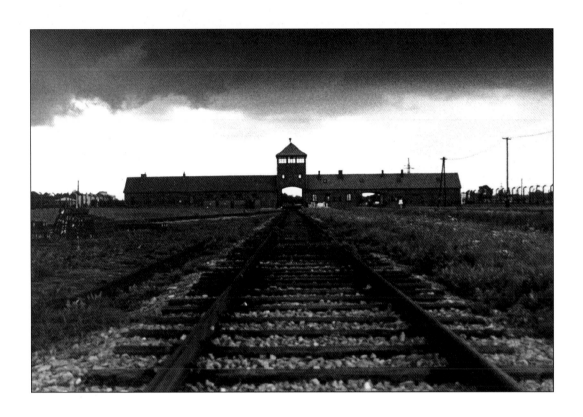

CONFISCATED SUITCASES, AUSCHWITZ I

WE TOOK THE TRAIN from Krakow back to Warsaw, our last stop before leaving Poland. Our suitcases were always in our sight since we were advised several times that many unemployed Poles earn their living snatching unattended luggage from travelers. As I gazed out at the countryside during the trip, impressions of our encounters of the past two weeks ran through my mind in rapid succession. In the end, it was clear that we had just completed a unique odyssey. I learned about my own roots in a way that only a journey to the source could teach. It was also clear that my children had developed a sense of their legacy that an oral history alone could not provide.

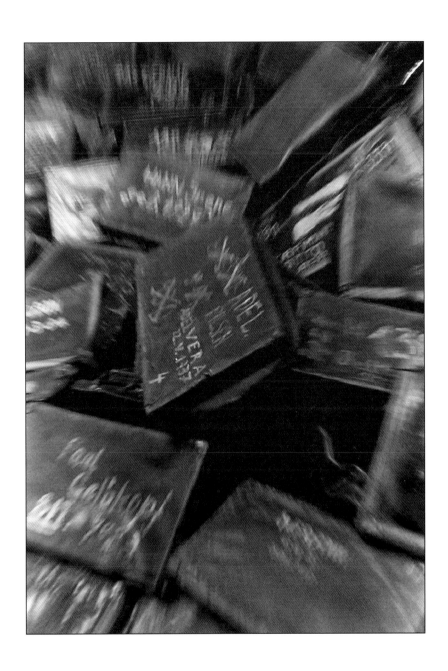

WARSAW

AT THIS POINT, I've been able to process the film that I exposed along the way. I don't expect to fully process all the experiences that I had for years to come.

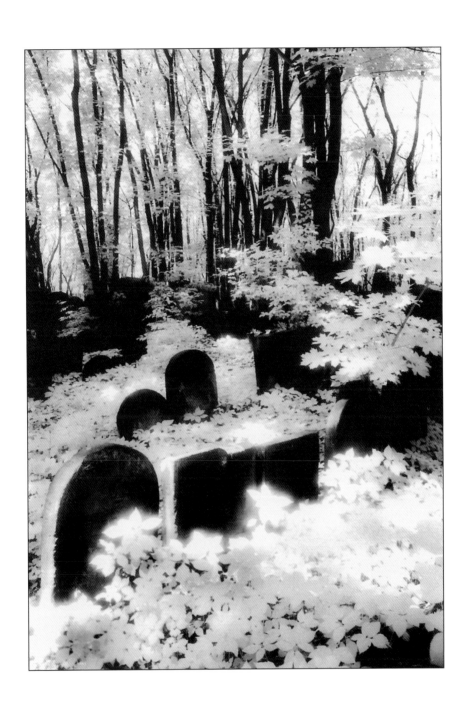

Notes

Bricha - (*Hebrew, lit. "flight, escape"*) underground organized movement of Jewish Holocaust survivors from eastern Europe to **DP camps** with the avowed aim of reaching Palestine and re-building the Jewish national homeland.

Hebrew Immigrant Aid Society (HIAS)- prominent Jewish immigrant assistance agency.

Displaced Persons (DP) Camp - refugee centers established after the end of World War II in the Allied zones of occupation in Europe. DP's were largely Jews from eastern Europe, primarily Poland, who were not prepared to resume life in the anti-Semitic environment of their former homes. They organized groups with their own national consciousness and political objective: to be able to emigrate—hopefully, to Palestine.

Palestine - one of the names of the territory formerly known as the ancient Land of Israel or Holy Land. It was part of the Ottoman Empire until 1922, when the British, who received the Mandate over Palestine by the League of Nations, restricted use of the name to that land west of the Jordan River, while establishing the emirate of Transjordan on the east bank. In 1948 the State of Israel was established in a part of western Palestine.

Kaddish - prayer which has as its underlying thought the hope for the redemption and ultimate healing of the suffering of mankind. It is traditionally recited by mourners.

Ghetto - walled-in, enclosed and guarded "Jewish Quarter." These were established by the Nazis as areas where Jews who were city inhabitants, as well as those who were from the surrounding areas, were forced to live and work under inhumane and desperate conditions. It also served as a transfer station for deportation to forced labor and death camps.

Gymnasium - middle school.

Zionist - proponent of the movement to re-establish a Jewish national homeland in the ancestral land of Israel.

Mauthausen - concentration camp created in 1938 near an abandoned stone quarry in Upper Austria. Of the 200,000 inmates who passed through, almost 120,000 perished before liberation by the Allies in May, 1945.

Aron Kodesh - decorated holy ark housing the Torah scrolls (containing the teachings of the five books of Moses), located at the eastern wall of the synagogue. It is the focus of one's prayers when the Torah is not being read.

Magen David - six pointed Star of David. This symbol was affixed to clothing identifying Jews in occupied Europe and is currently featured prominently on the Israeli flag.

Aktion - operation involving the mass assembly of Jews for deportation and murder during the Holocaust.

Nazi - short term for the National Socialist German Workers' Party, a right wing political party formed in 1919. Adolph Hitler became head of the party in 1921, and under his leadership the Party became a powerful political force in German elections by the early 1930's. The Nazi ideology was strongly anti-Communist, anti-Semitic, racist, nationalistic and militaristic.

Majdanek - concentration camp covering 2.7 sq. kms. on the outskirts of Lublin on the Lublin-Zamosc-Chelm highway. Estimates are that 360,000 of the 500,000 people who passed through the camp perished. Most succumbed to conditions in the camp—starvation, exhaustion, disease; others were put to death in gas chambers or executed.

Yad Vashem - (*Hebrew, lit. "a monument and a name"*) Israeli national institution of Holocaust commemoration in Jerusalem. It is dedicated to the six million Jews murdered by the Nazis, to the destroyed Jewish communities and institutions, to the heroism of the soldiers, fighters in the underground, prisoners in the ghettos, and to the **Righteous Among the Nations**, who risked their lives to save Jews. A visit to *Yad Vashem* is part of the program for official guests on state visits to Israel.

Schindler's Jews - workers in Oscar Schindler's enamelware factory in Zablocie, on the outskirts of Krakow who were shielded from deportations to the Plaszow labor camp. Schindler was a German businessman who was devoted to the humane treatment of his Jewish workers. He used his good connections in the German government and military to ameliorate some harsh conditions for the Jews under his control. Approximately 1,100 Jews owe their survival to Schindler. In 1962, a tree was planted in his honor at ***Yad Vashem***.

Kazimierz Jewish Quarter - prior to WWII, the center of culture and social life for Krakow's Jewish population. The Polish King Kazimierz welcomed the Jews to his city after their expulsion from Spain in 1492.

Wailing Wall or Kotel - last remnant of the ancient Temple in Jerusalem. It was destroyed by the Romans and is considered the holiest site for Jews.

Gabbai - coordinates activities during a service; gives out honors, assists the Torah reader, may chant some of the prayers.

U.S. Holocaust Memorial Museum - chartered by a unanimous Act of Congress in 1980, supported by the Carter, Reagan, Bush and Clinton Administrations, and built entirely with private funds. This is America's newest national Museum. Its purpose is the documentation, study and interpretation of Holocaust history, and it serves as this nation's memorial to the millions of innocent victims murdered during the Holocaust.

Blitzkrieg - lightning, massive offensive of German forces into Poland on September 1, 1939, marking the start of WWII. All of Poland was under German control within three weeks.

Oswiecim - Polish town near Krakow renamed Auschwitz by the Nazis during the occupation.

"Arbeit Macht Frei" - *(German, lit. "work makes you free")* infamous and insidious inscription over the entrance to ***Auschwitz I***.

Gas Chambers - method used by the Nazis for "efficient" mass murder. Both mobile and stationary gas chambers were put into use. The method was launched at Chelmno in December, 1941 using mobile vans that had been constructed and equipped for this specific purpose.

Crematoria - specially designed ovens, usually adjacent to the *gas chambers*, for the purpose of burning corpses. German firms, such as J. A. Topfe & Sons, submitted bids to receive the contracts to build these facilities.

Final Solution - term used as a code word for the extermination of the Jews. The plan was finalized at the Wannsee Conference in 1942.

I.G. Farben - conglomerate of eight leading German chemical companies, including Bayer, Hoechst and BASF, that joined with the *Nazi* regime to build a vast industrial complex at *Auschwitz* for the production of synthetic rubber and oil to propel Hitler's war machine. I.G. used the limitless reservoir of death camp labor at their plants. After the war, 24 of I.G.'s highest officials were indicted for war crimes at the Nuremberg Trials.

Buna - synthetic oil and rubber factory operated by the *I.G. Farben* conglomerate at *Auschwitz III*.

Cameras:	Nikon FE w/ Tokina 28-85mm lens
	Pentax Spotmatic w/ Takumar 28 mm lens
Film:	Tri-X, T-Max rated at ASA 200
	High Speed Infrared rated at ASA 50
Development:	D-76, D-76 1:2, Dektol 1:2
Prints:	8x10 Ilford Multigrade Fiber base
Development:	Dektol 1:2

ABOUT THE PHOTOGRAPHER . . . DAVID S. GREENFIELD

" Small crinkled edged black and white photos of Europe filled albums and boxes in my home when I was growing up. They were the product of my father's work with a Leica III camera in various refugee centers after the war. These simple pictures represented the world from which I came and were therefore very special to me. With my father's guidance, I gradually learned about film exposure and darkroom processing. It was in college, however, that my interest in photography went into high gear. By the time I graduated, I had worked my way through the ranks of the various publication staffs and served as photography editor for the school newspaper, quarterly magazine and yearbook. Although I love to emulate the style of photographic masters like Eisenstaedt, Capa and Cartier-Bresson as they capture 'the decisive moment', my work is primarily still life and landscape. The interplay of light and shadow as the day progresses fascinates me, and I strive to record on film that which might not be noted in passing."

Professionally, David is a periodontist with a practice in Stoughton, MA and a faculty position at the Harvard School of Dental Medicine. His photography has received recognition by the Boston, Newton and Stoughton Public Libraries, the National Audubon Society, Boston Museum of Science, Yankee Dental Congress, Countway Library of Medicine, as well as the Towns of Sutton and New London, N.H. He resides in Newton, MA with his wife Carol and children, Joshua and Naomi.

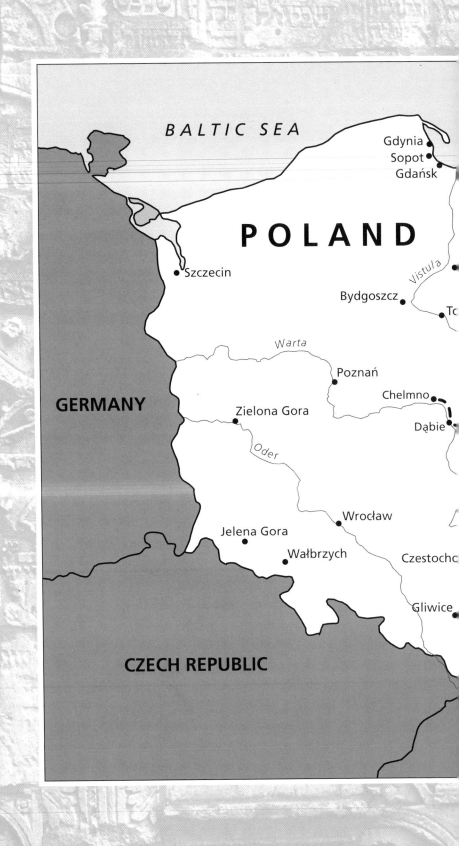